Beach Beauties

Fashion Sketchbook Collection

Adult Coloring books by S. Parks

VOLUME II

Reviews are always welcome. With this issue, I've named the models so that you can share your favorites in your reviews. Enjoy!

Cover and Interior Art by
Stephen A Parks ©2016

Thank you for buying this second edition of Fashion Sketchbook series; a coloring book collection of hand-drawn illustrations by Stephen A Parks.

Discover the full collection:
- Elven Beauties
- Beach Beauties
- Christmas Beauties {Coming December 2016}

Thanks to Jennifer for doing the final outlines.

GUINN

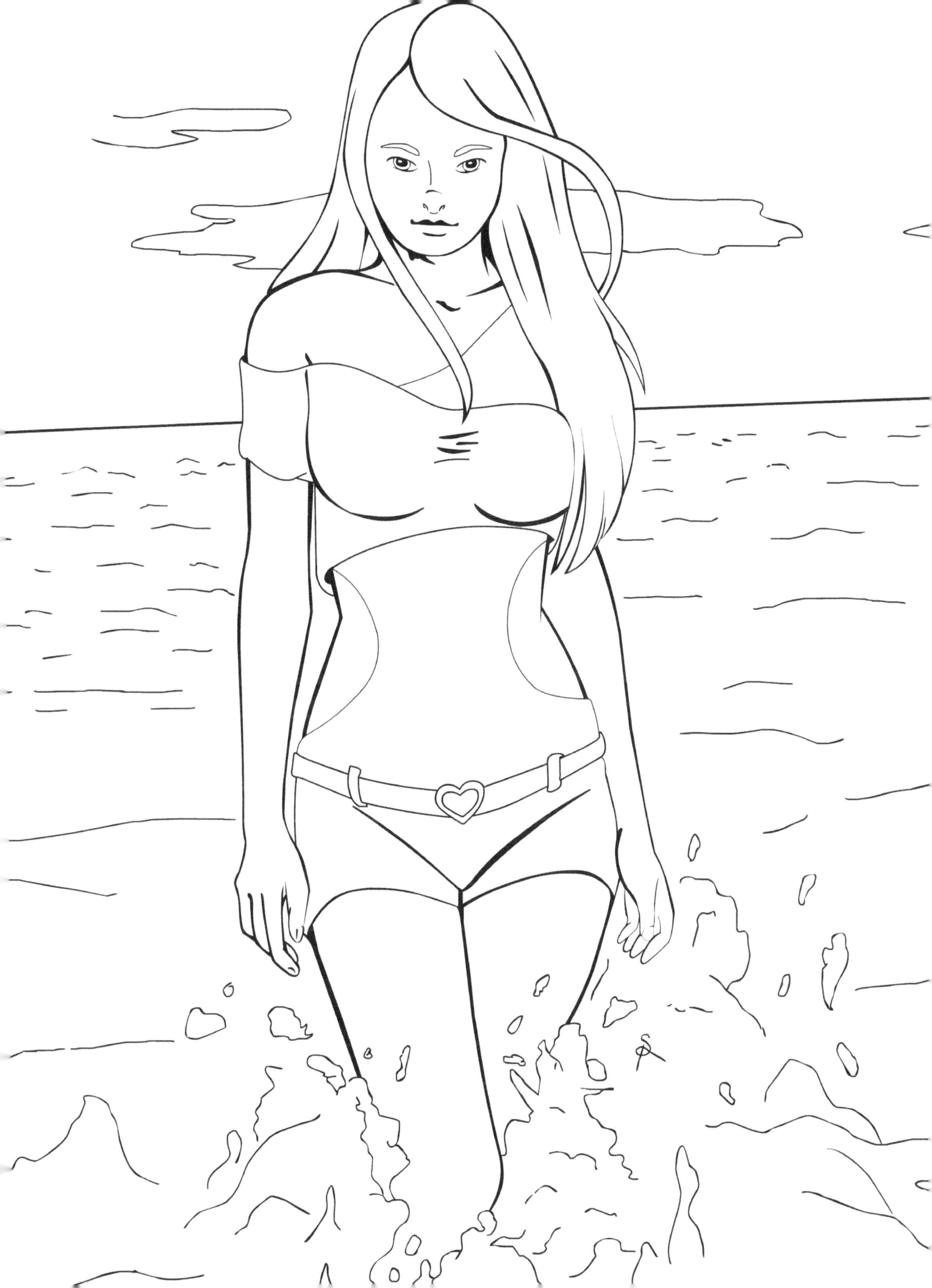

Rachel

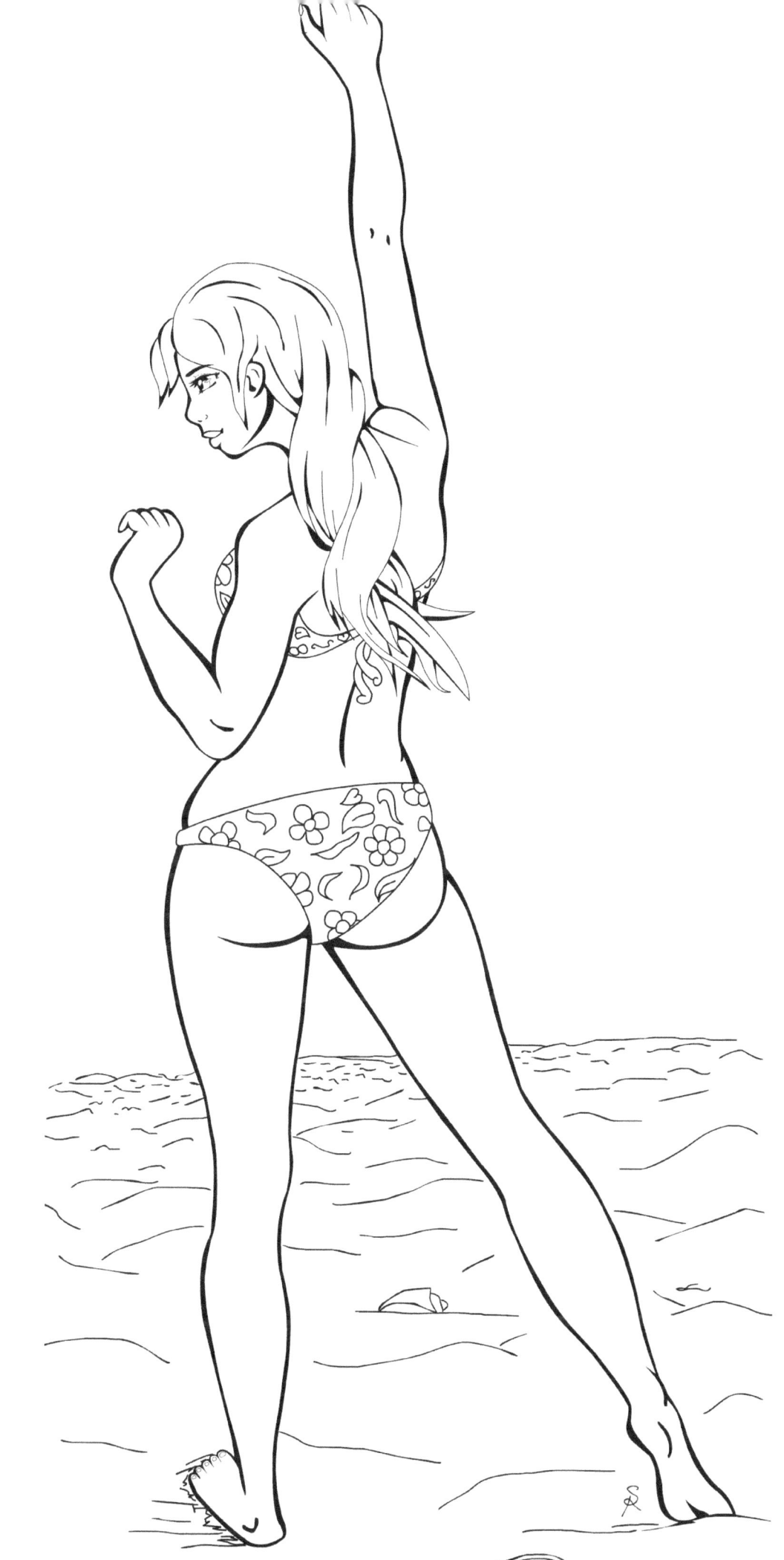

AYUUKO

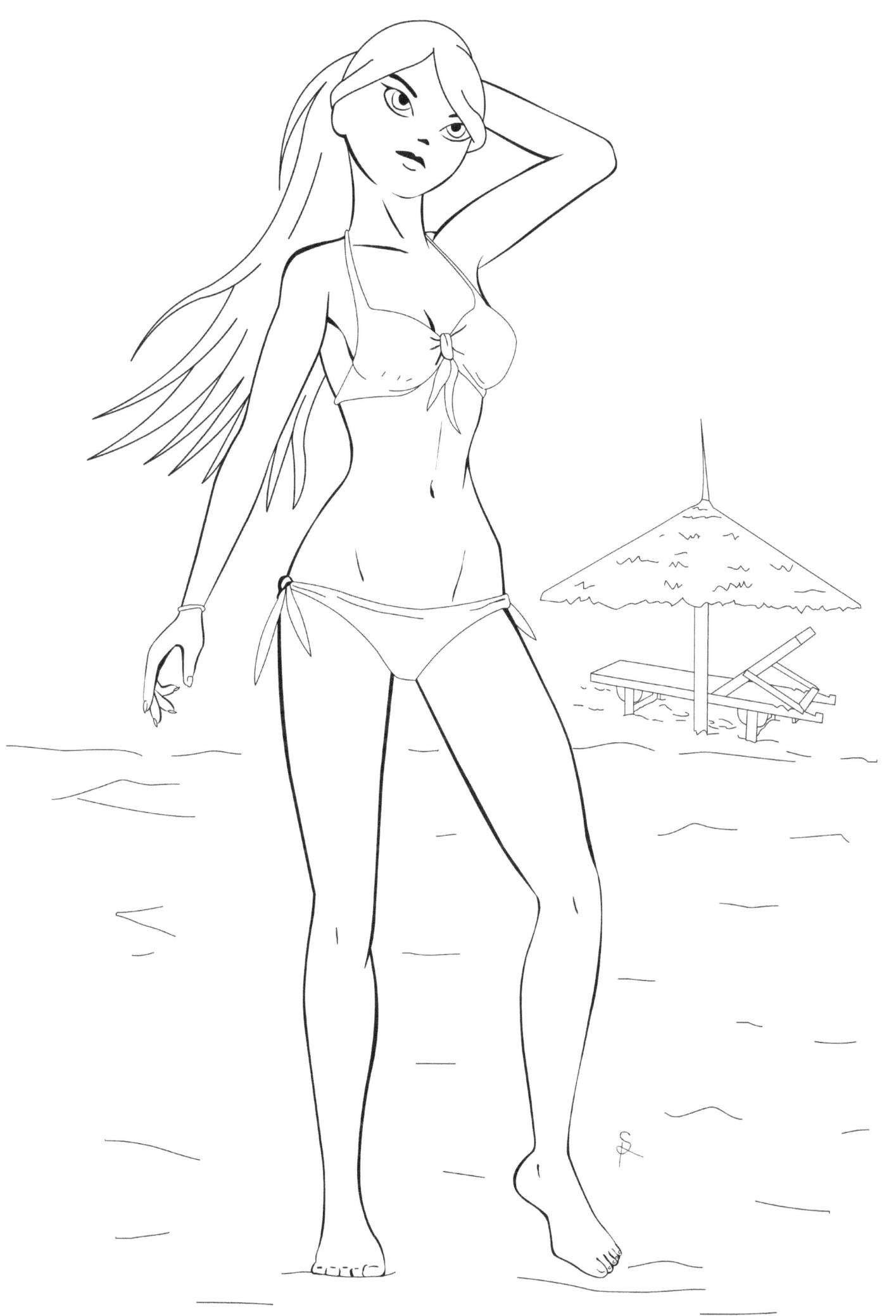

FARAH

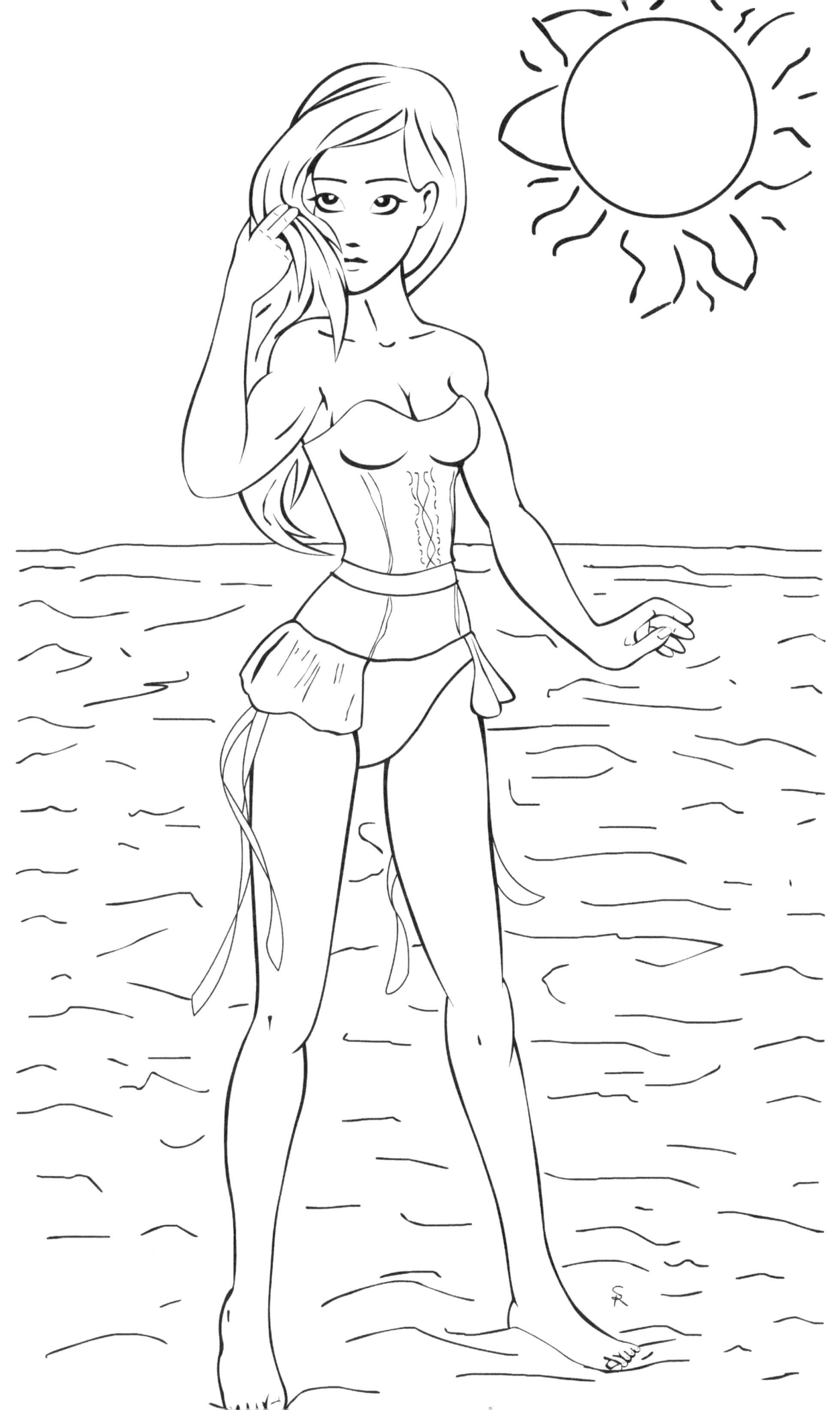

Acacia

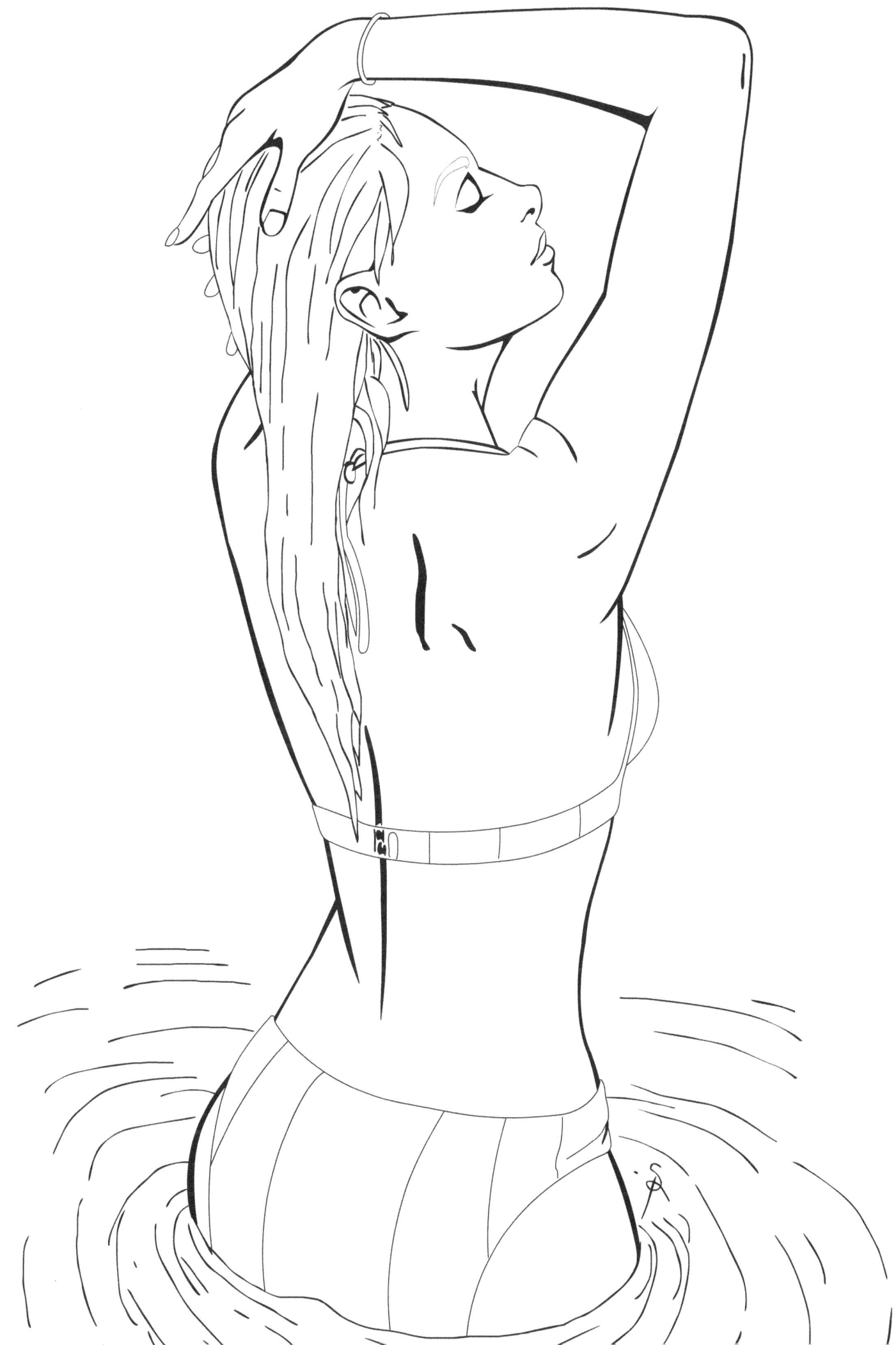

Sasha

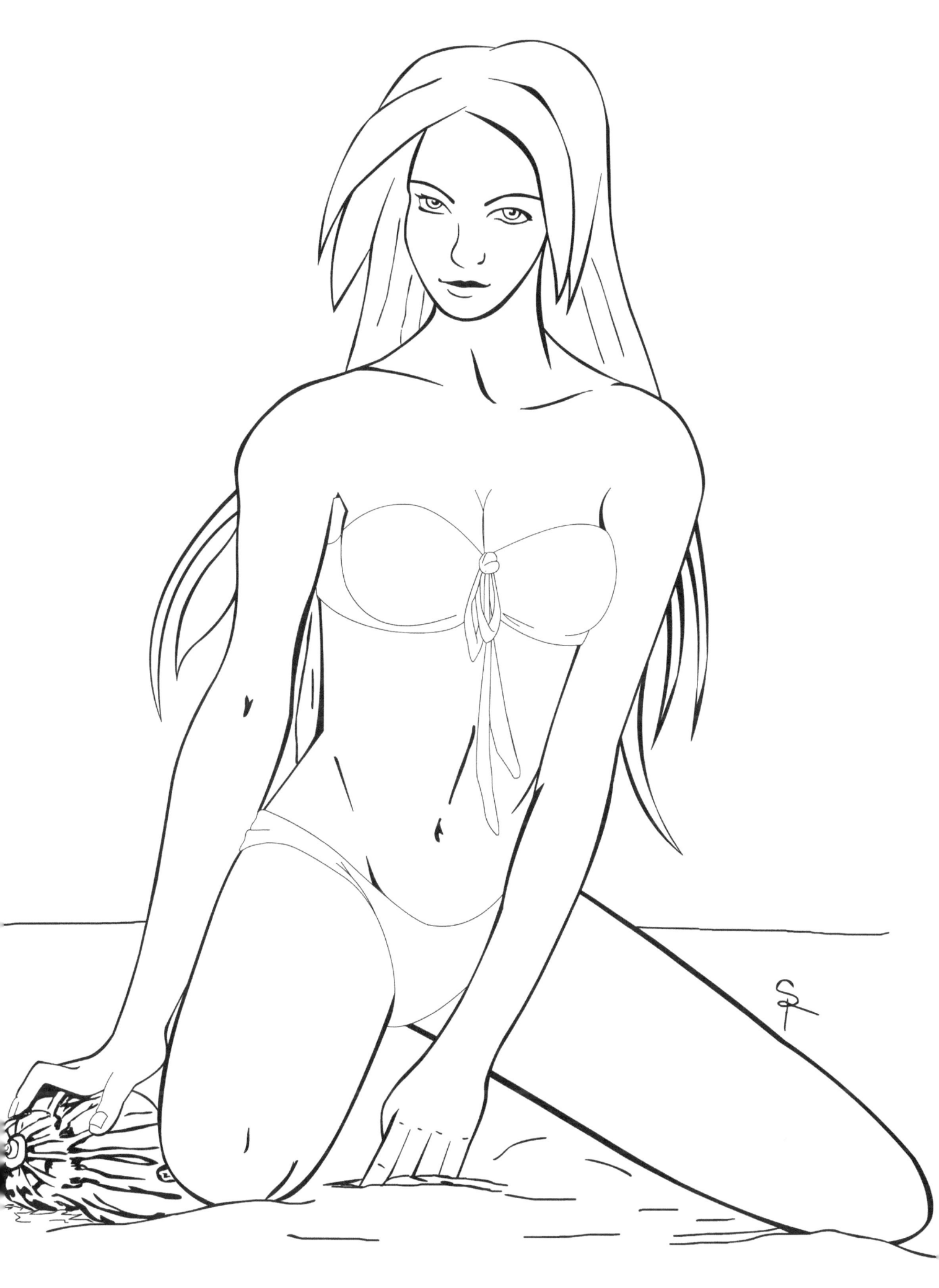

Karra and Ty

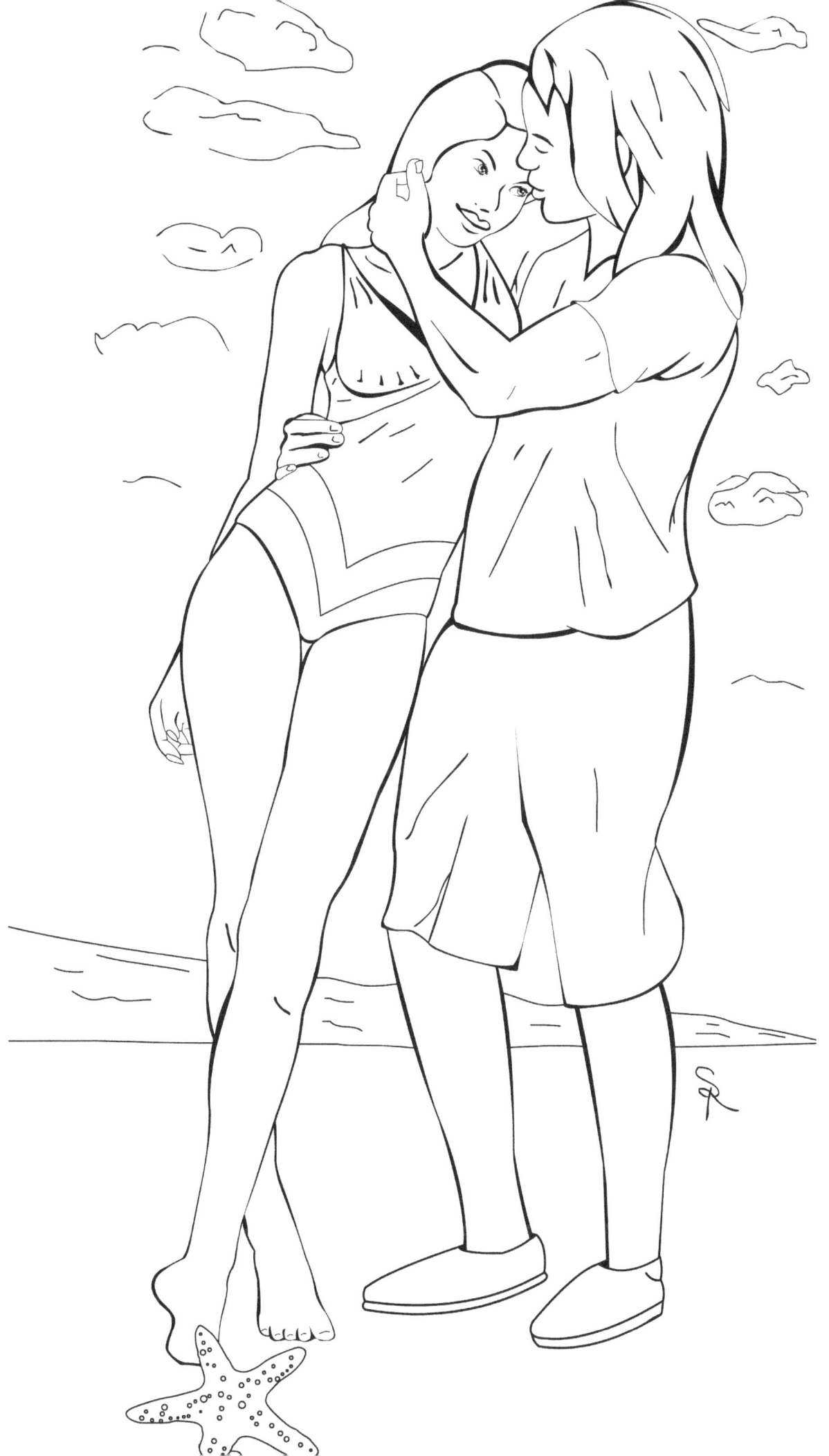

Ren

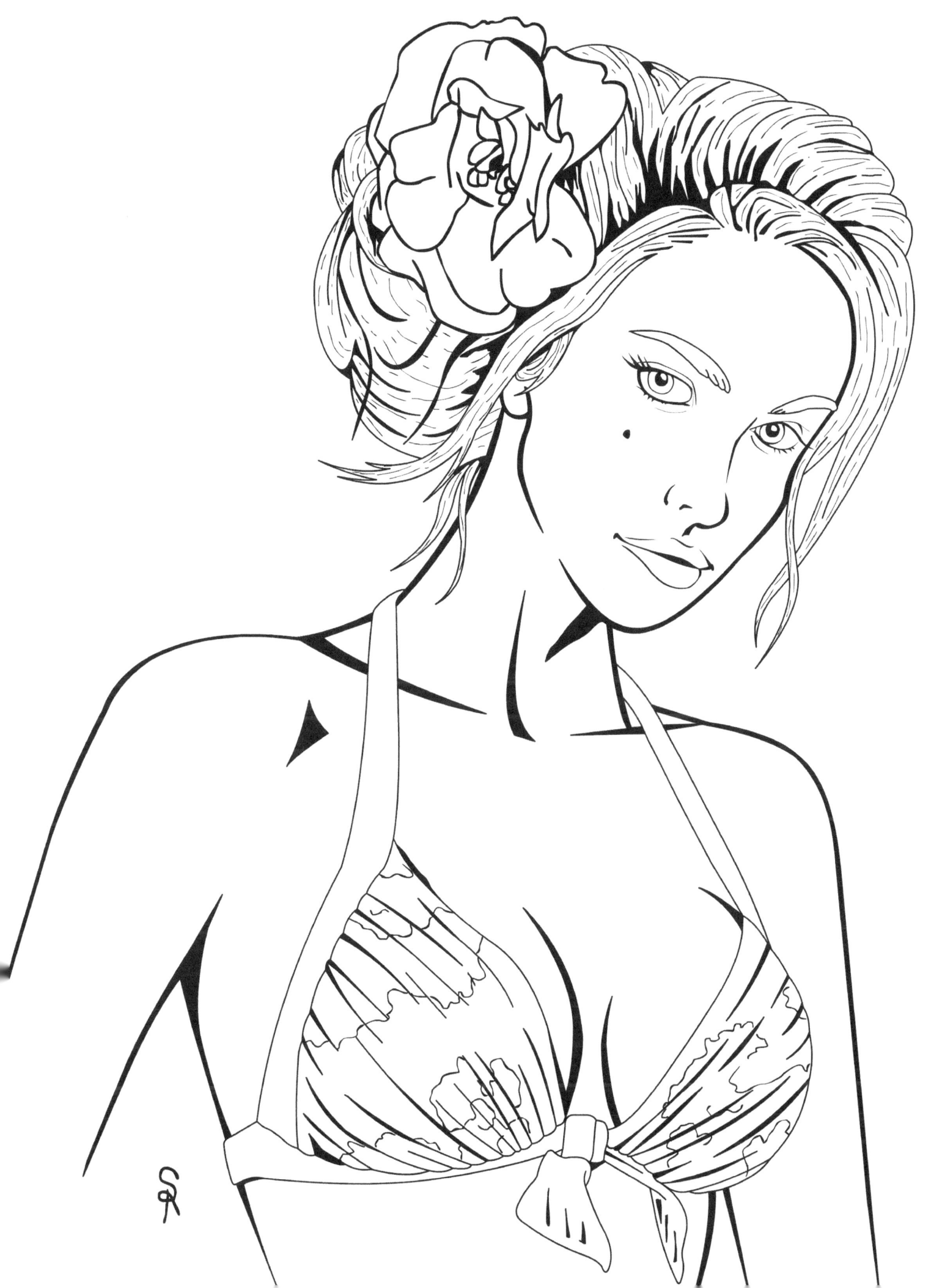

Sade

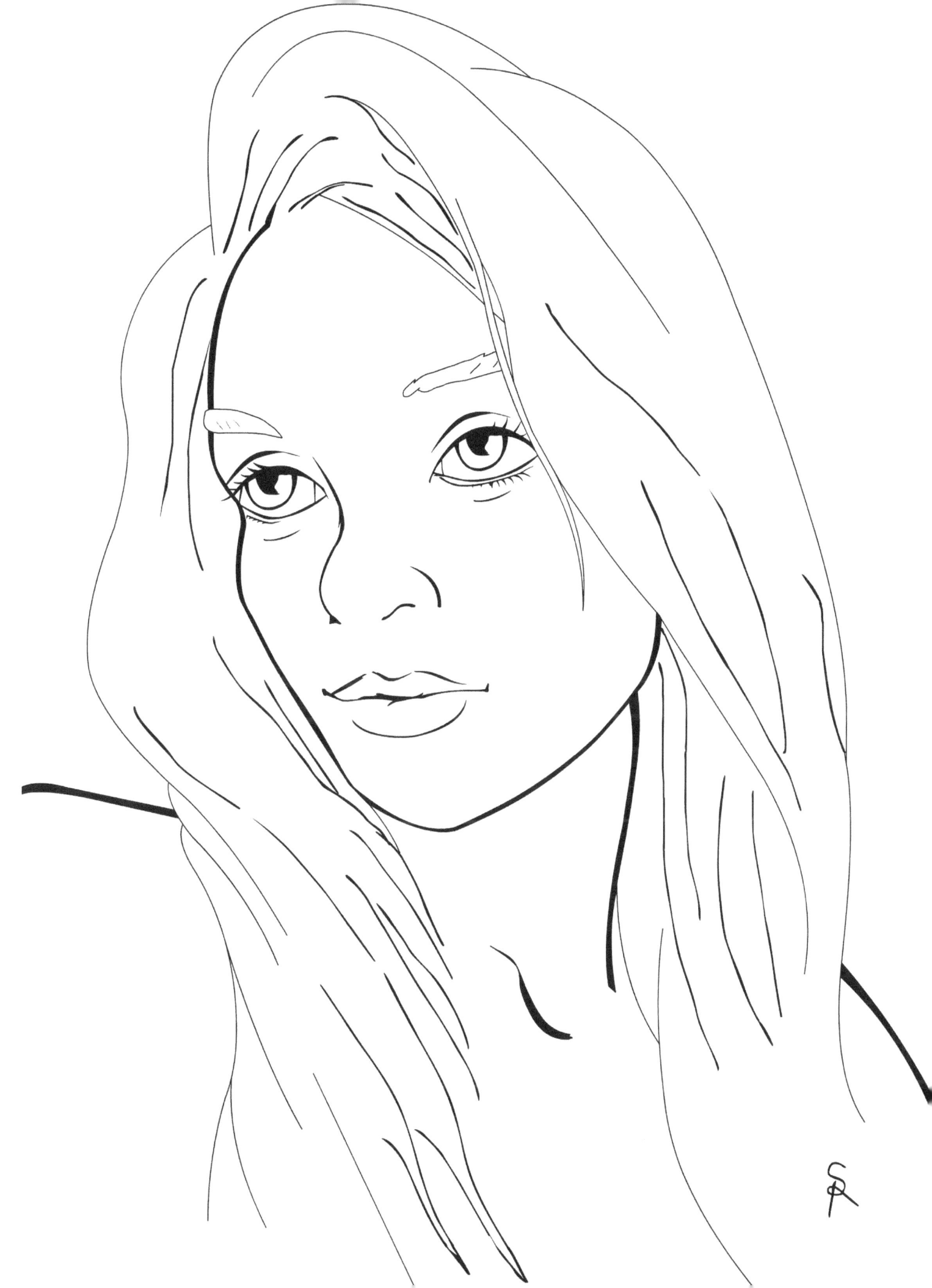

Prisilla

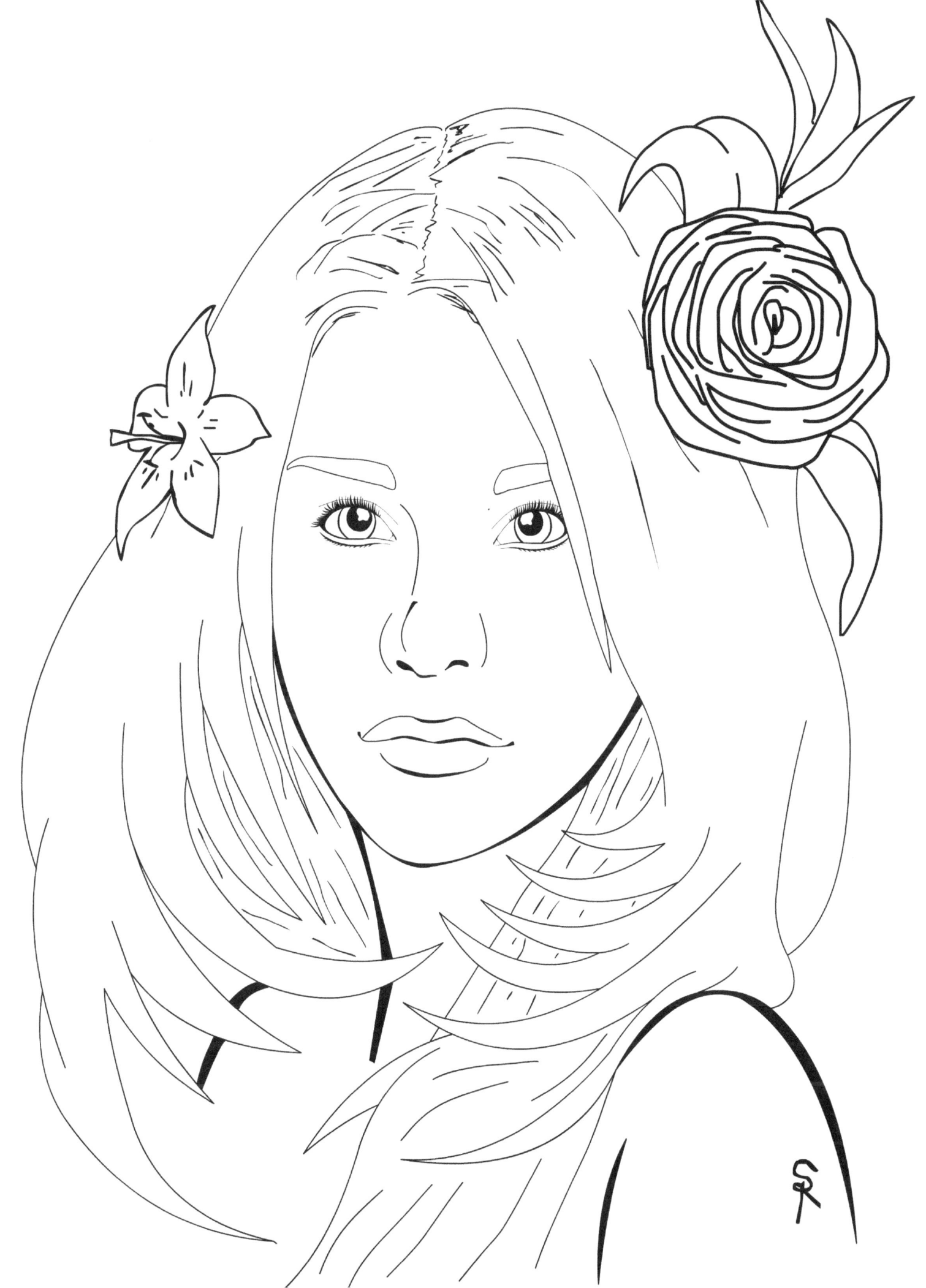

JOSELYNN

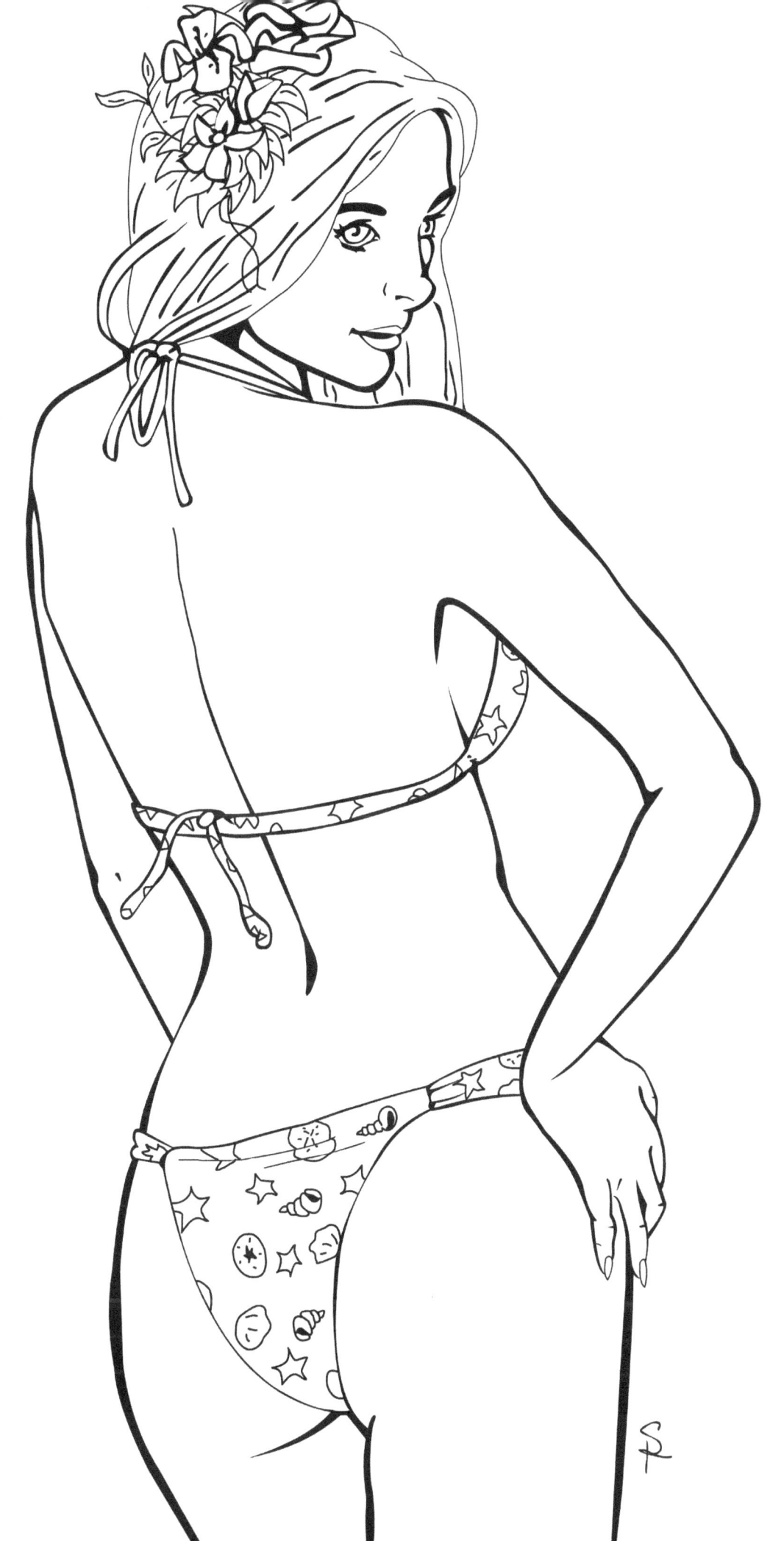

Jenni

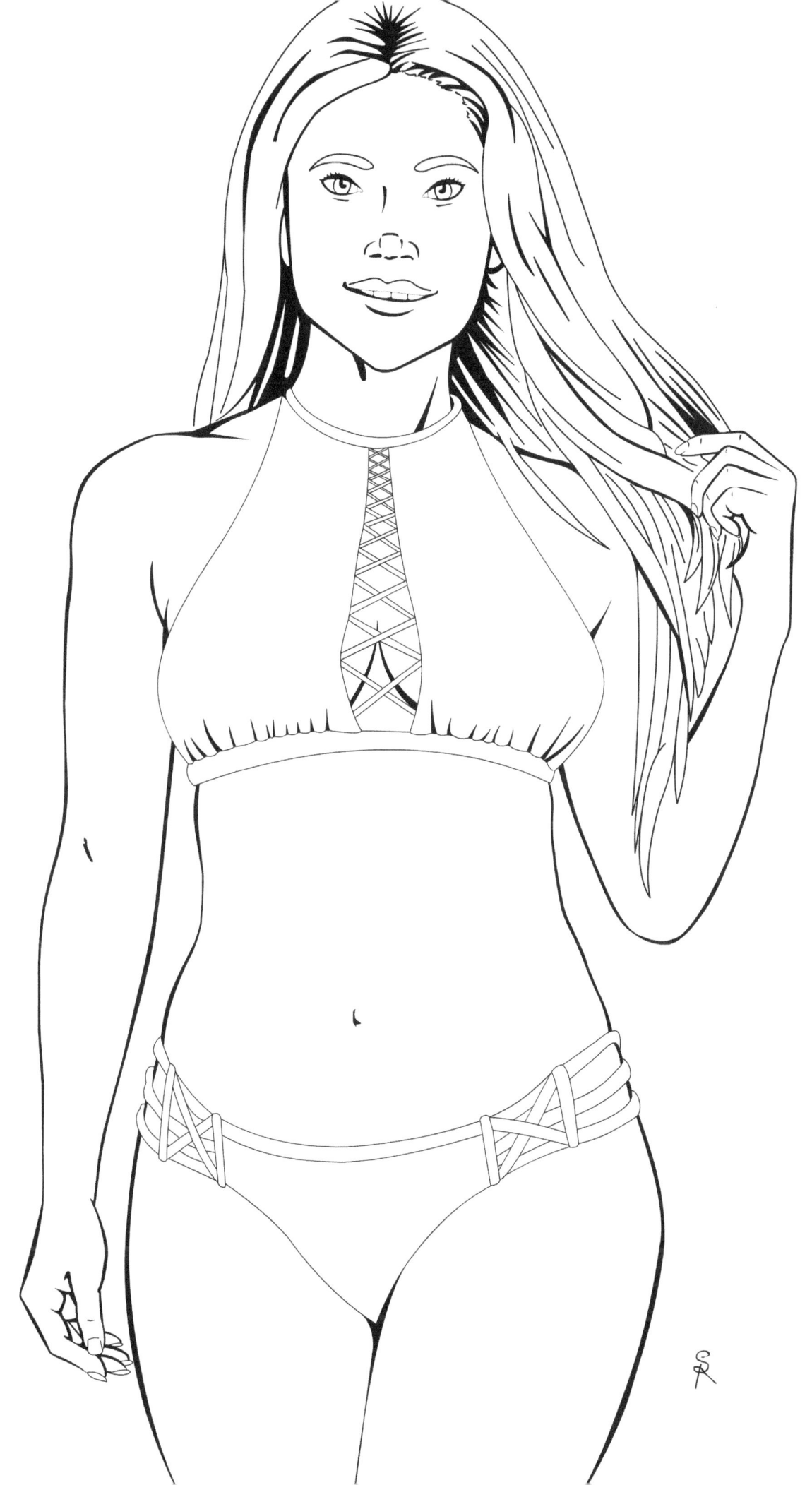

Penelope

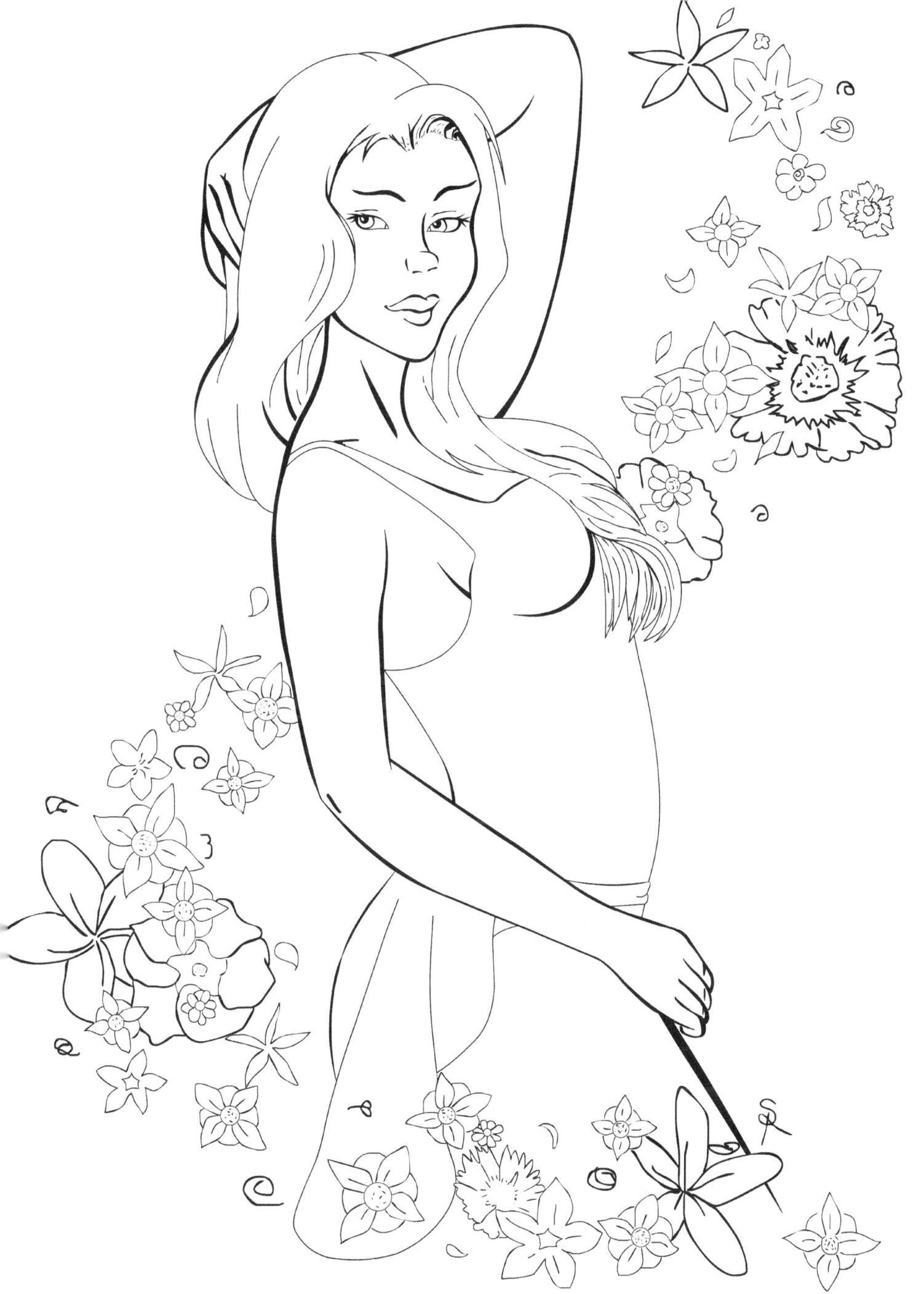

Wendy

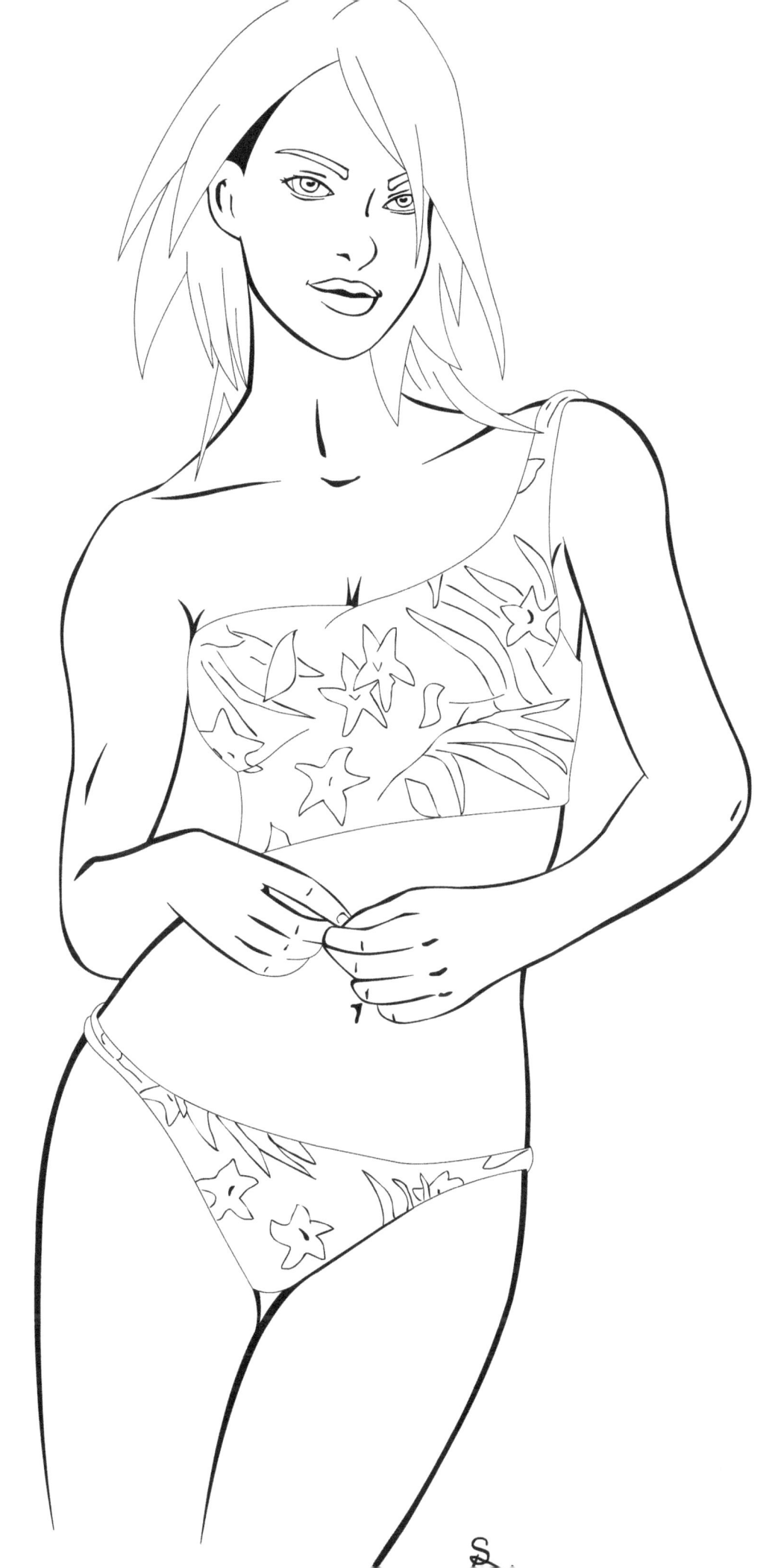

ALANI

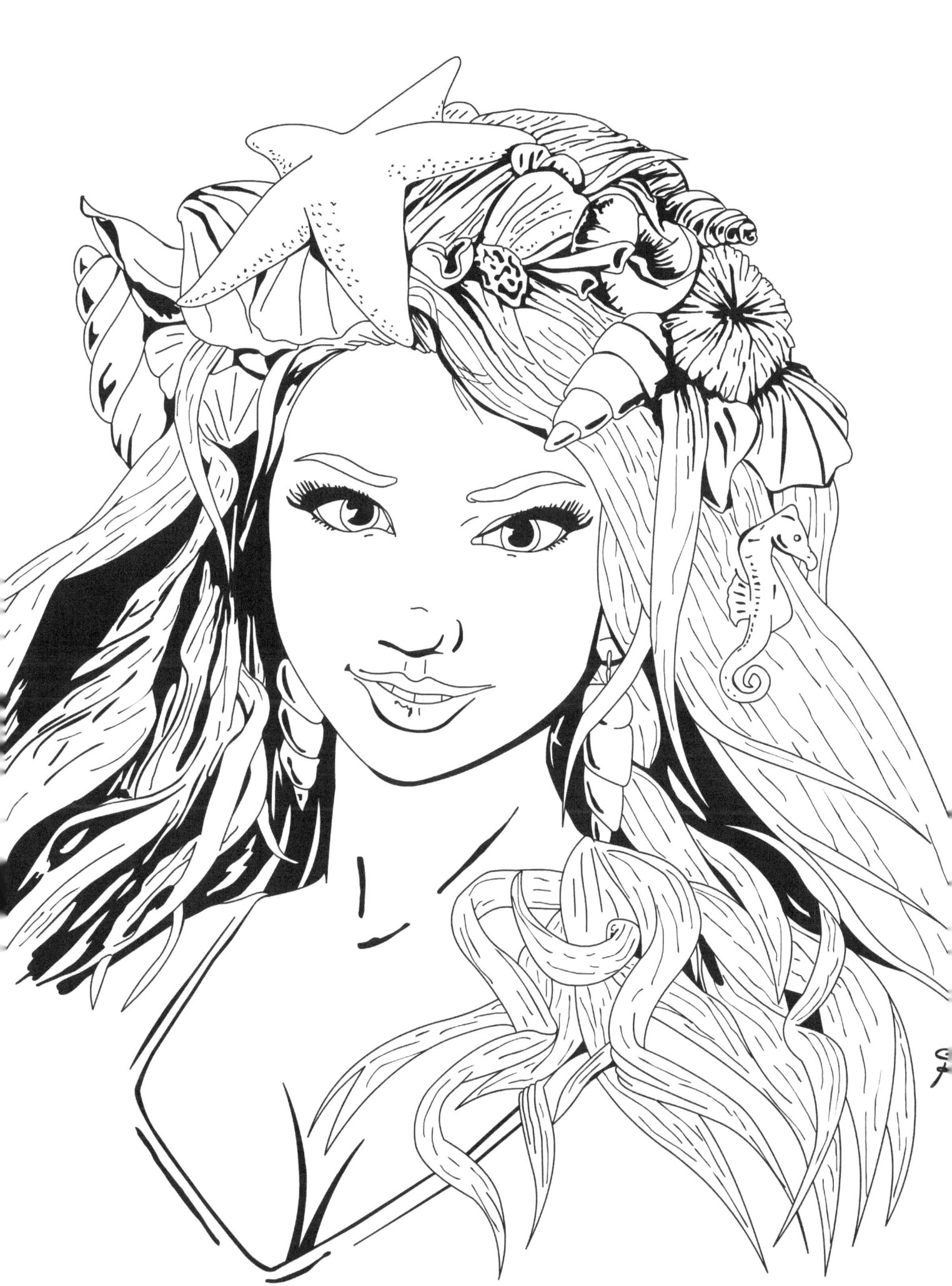

LAYLA

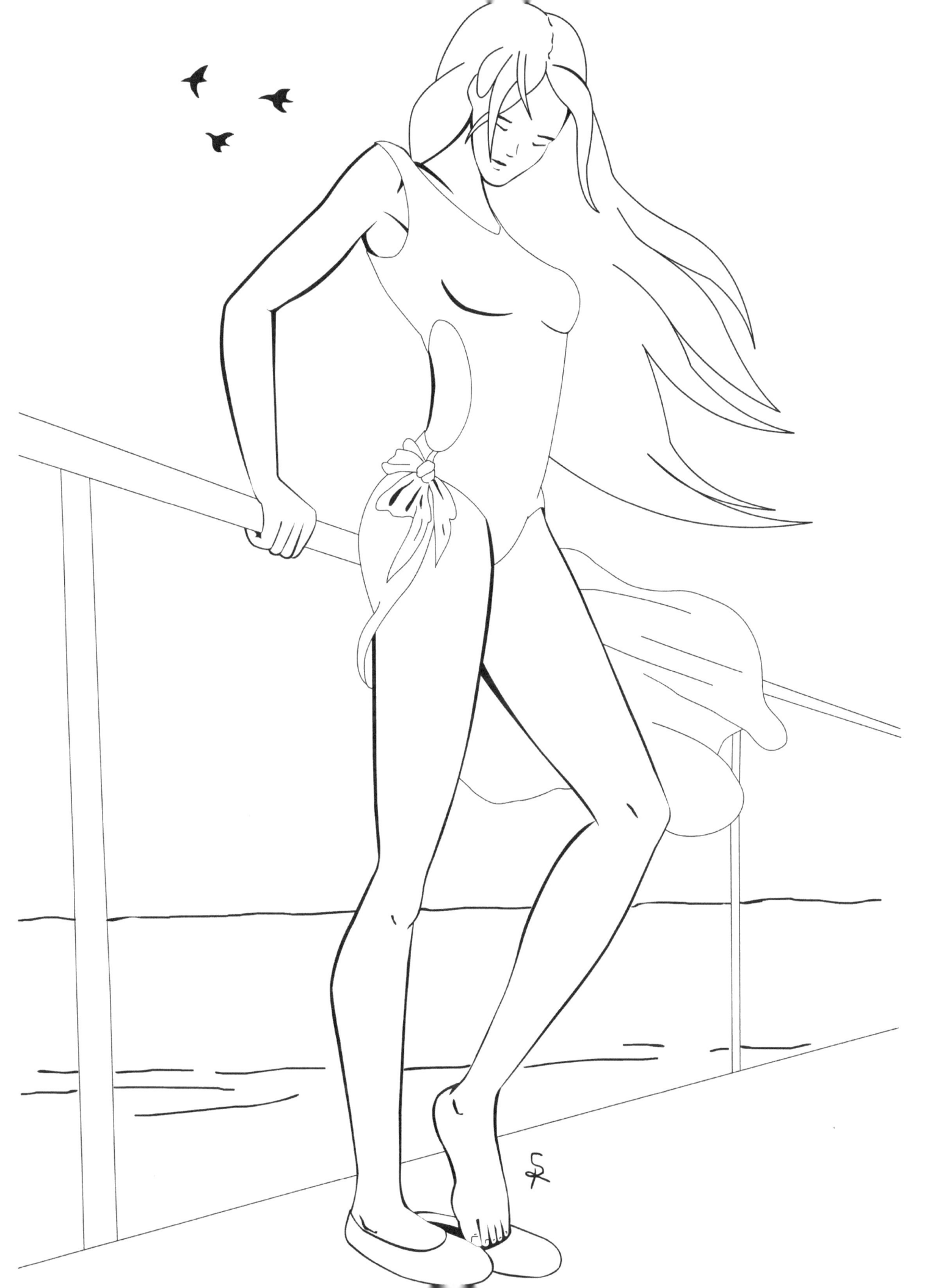

Jenna

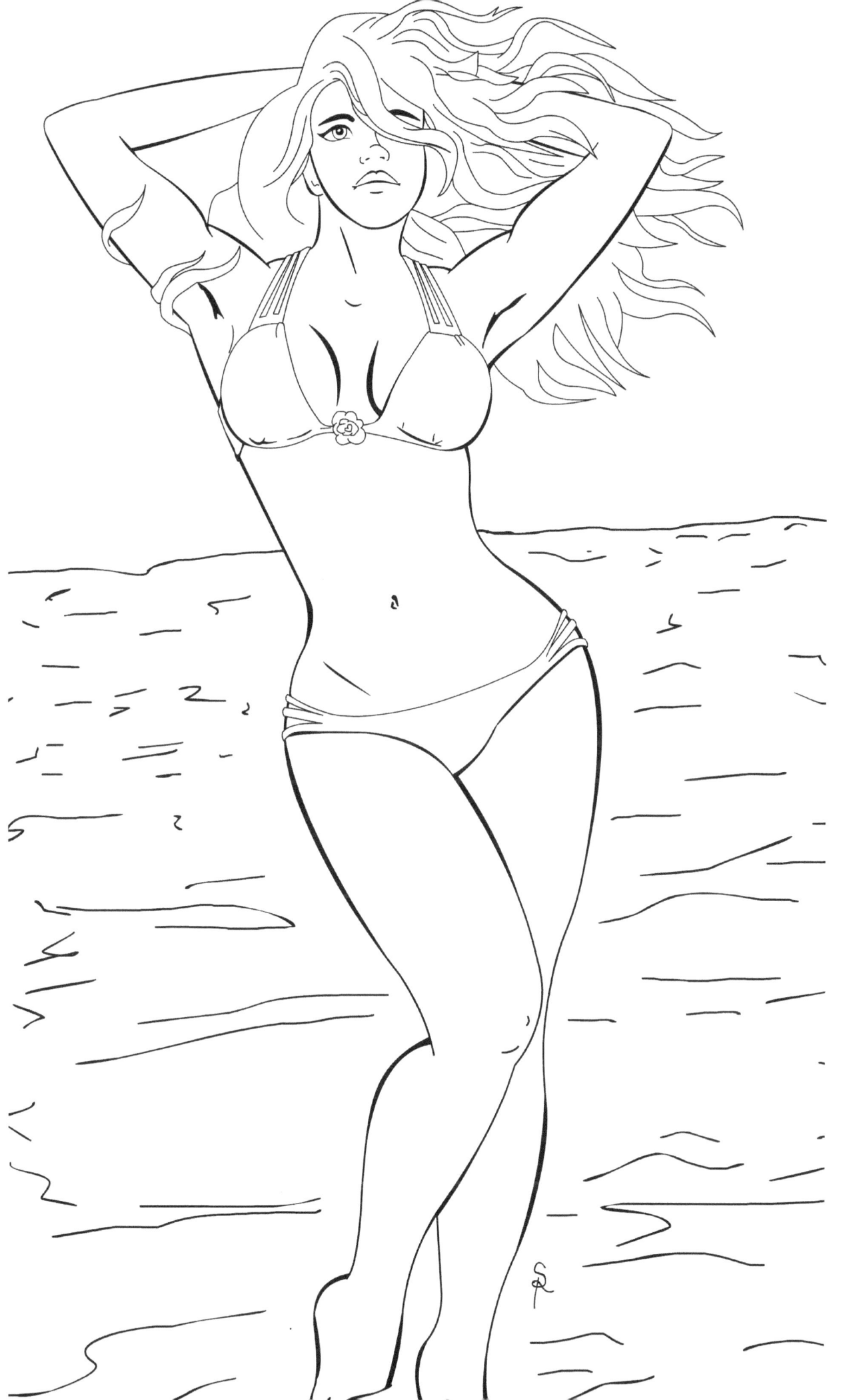

Lexi

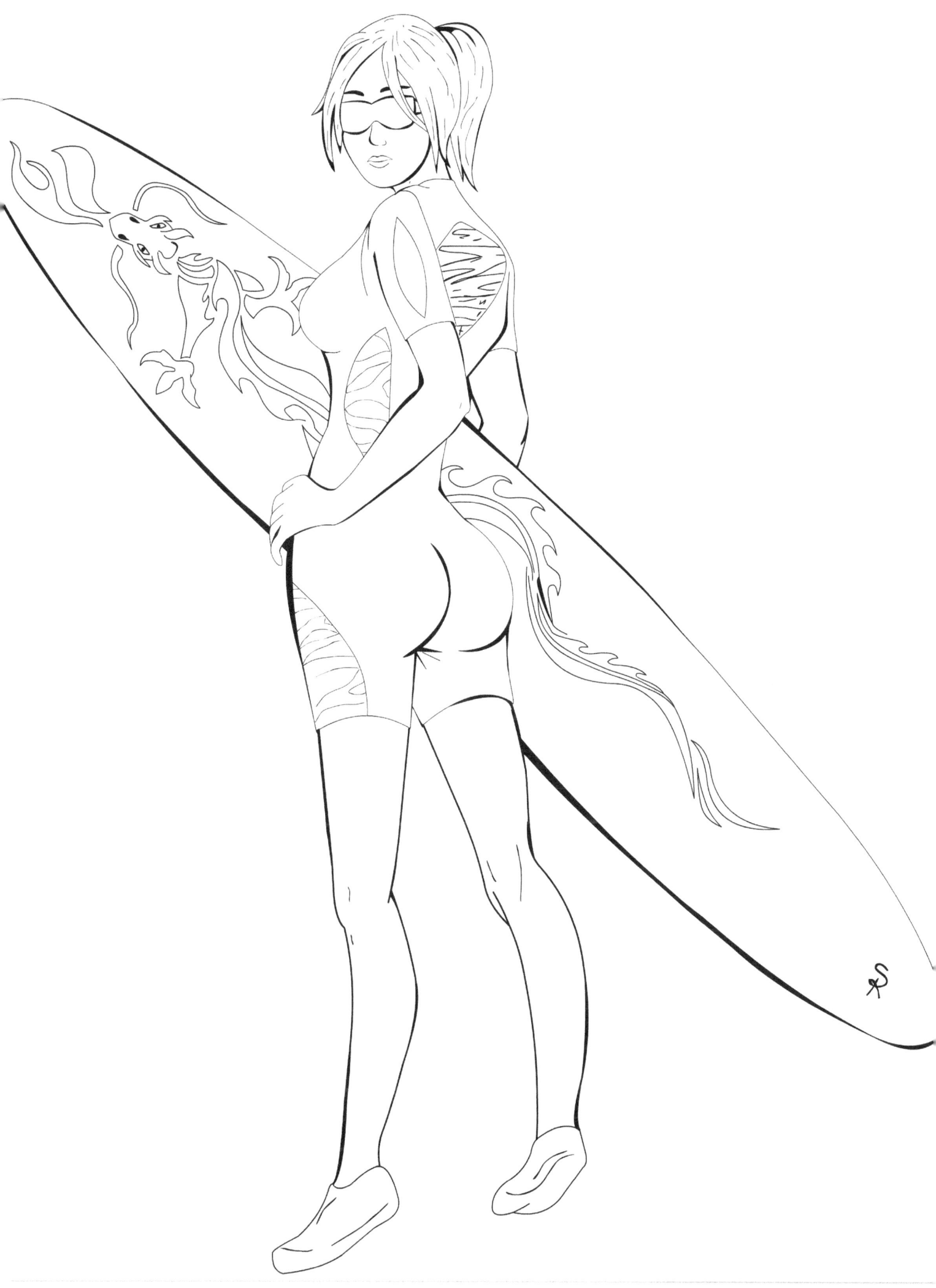

Anabel

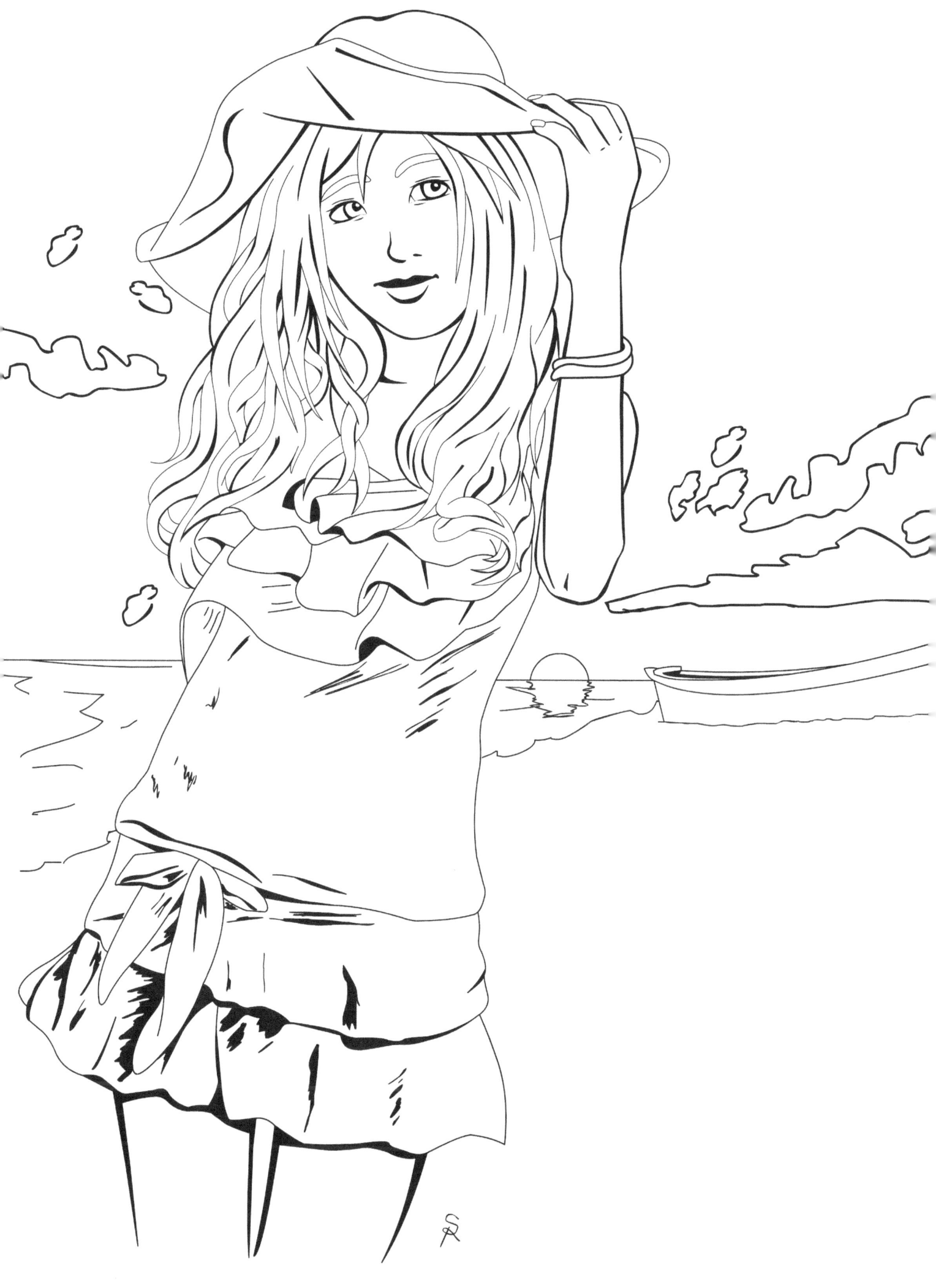

Janicka

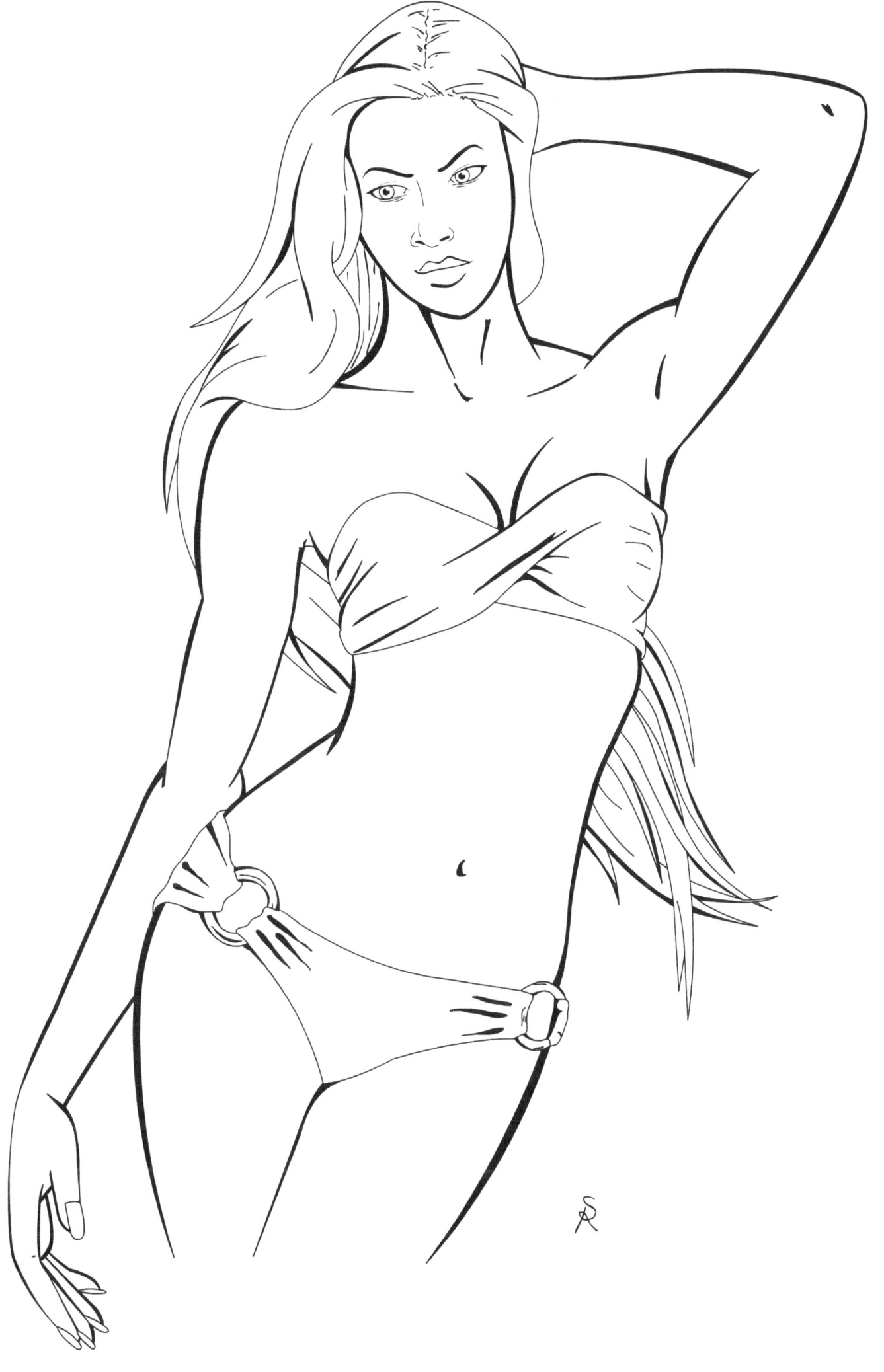

Reanna and Ferris

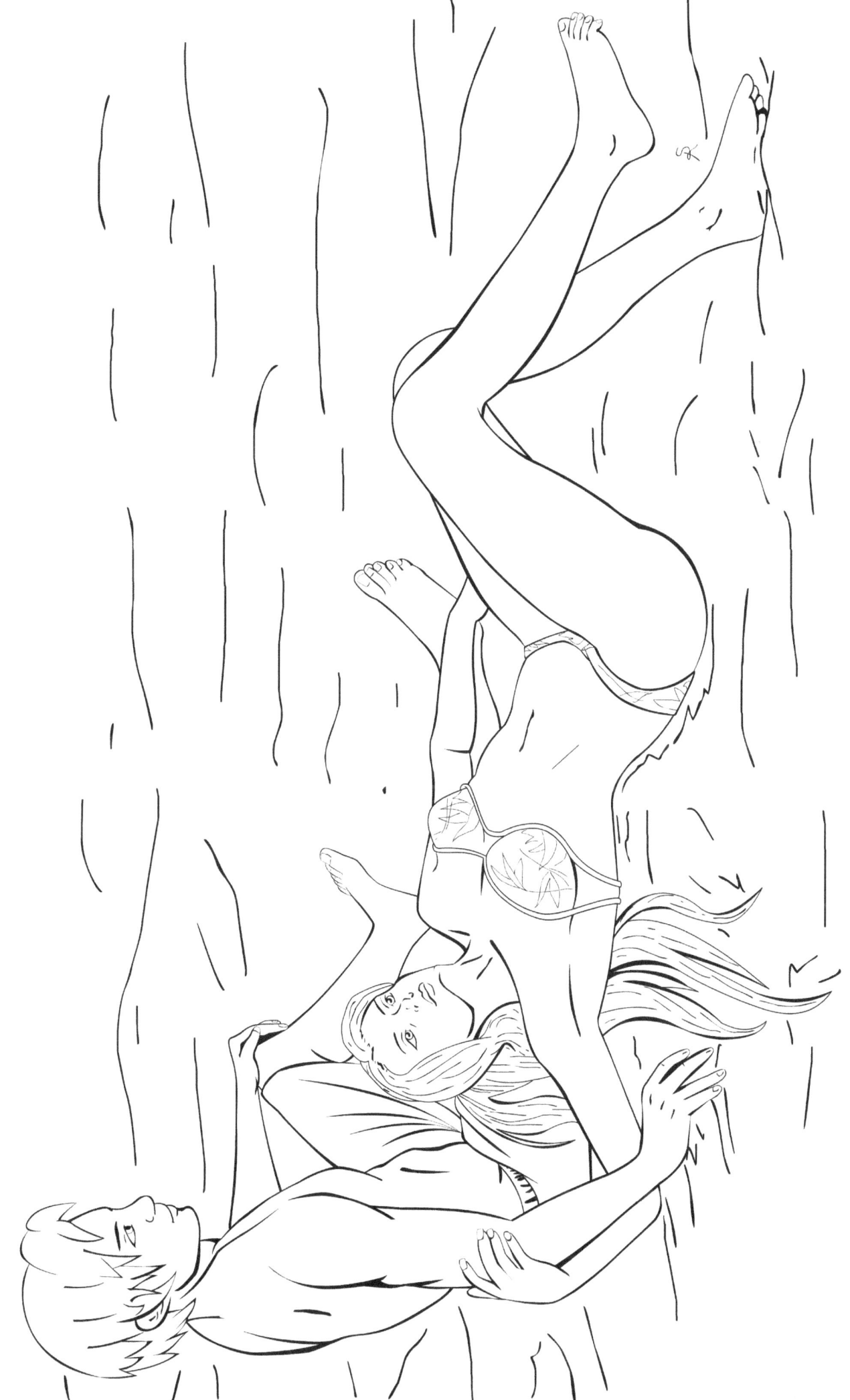

DJAMILA

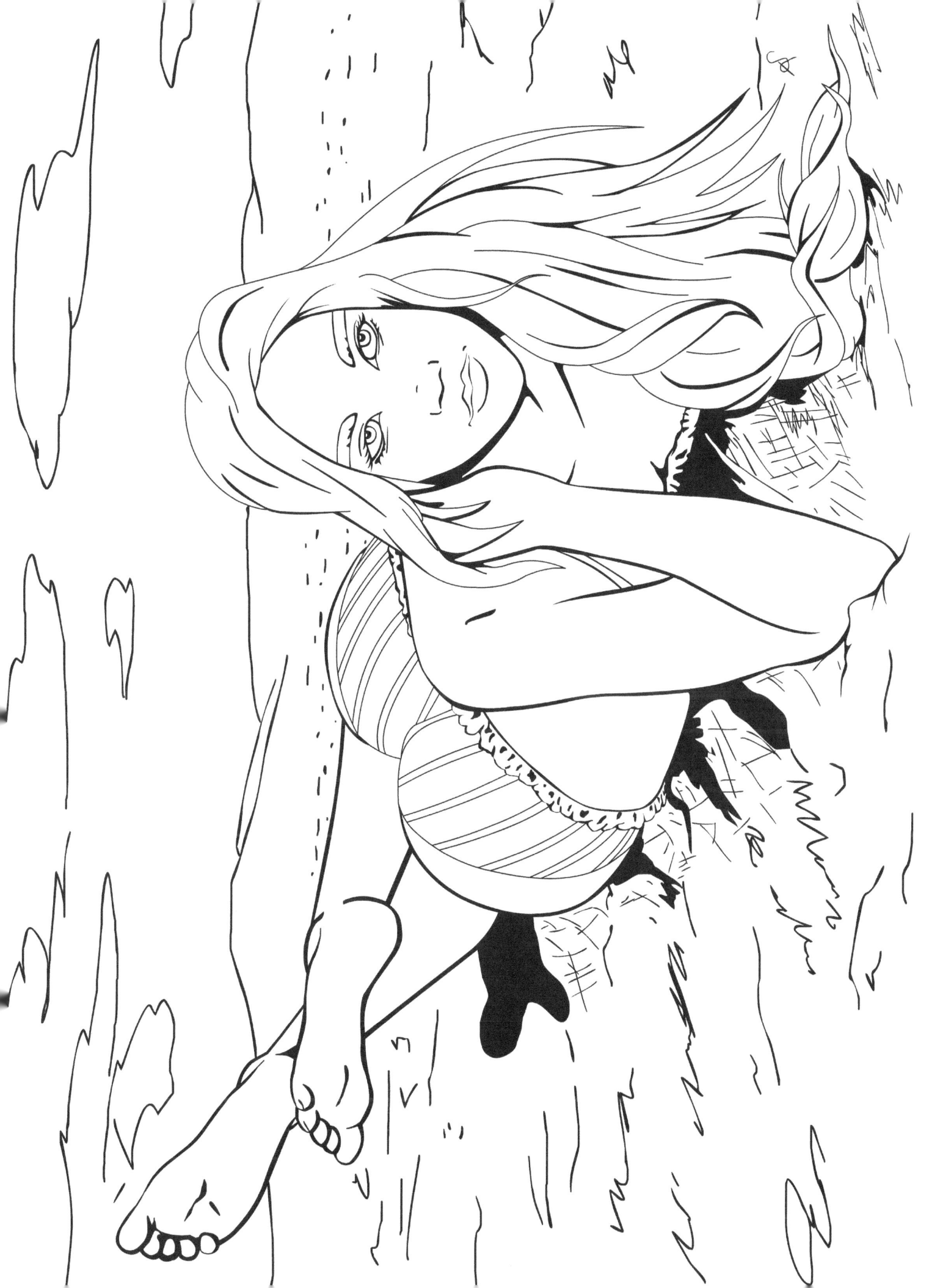

TAMARA

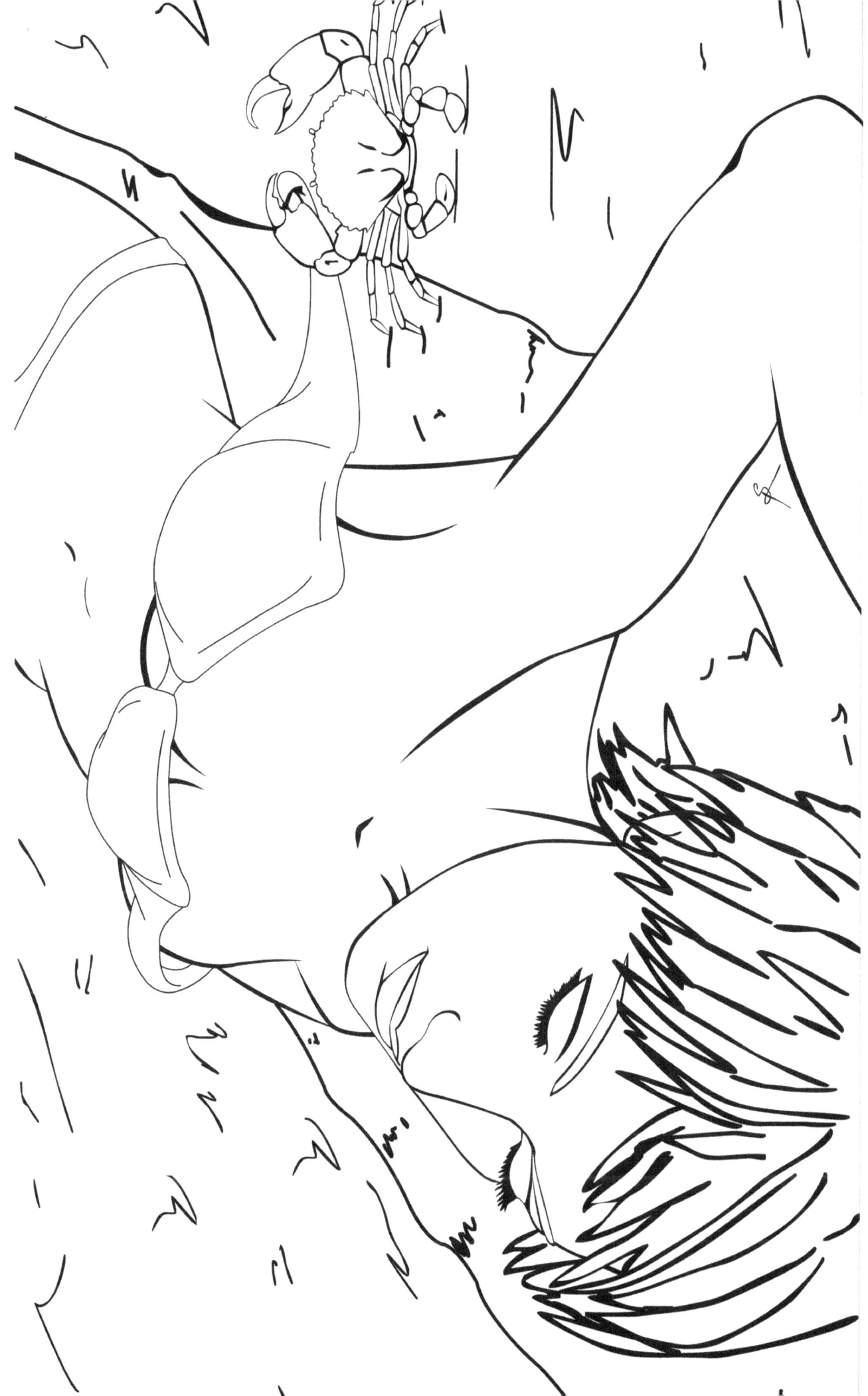

Thank you!
Look forward to my next book; Christmas Beauties, coming December 2016

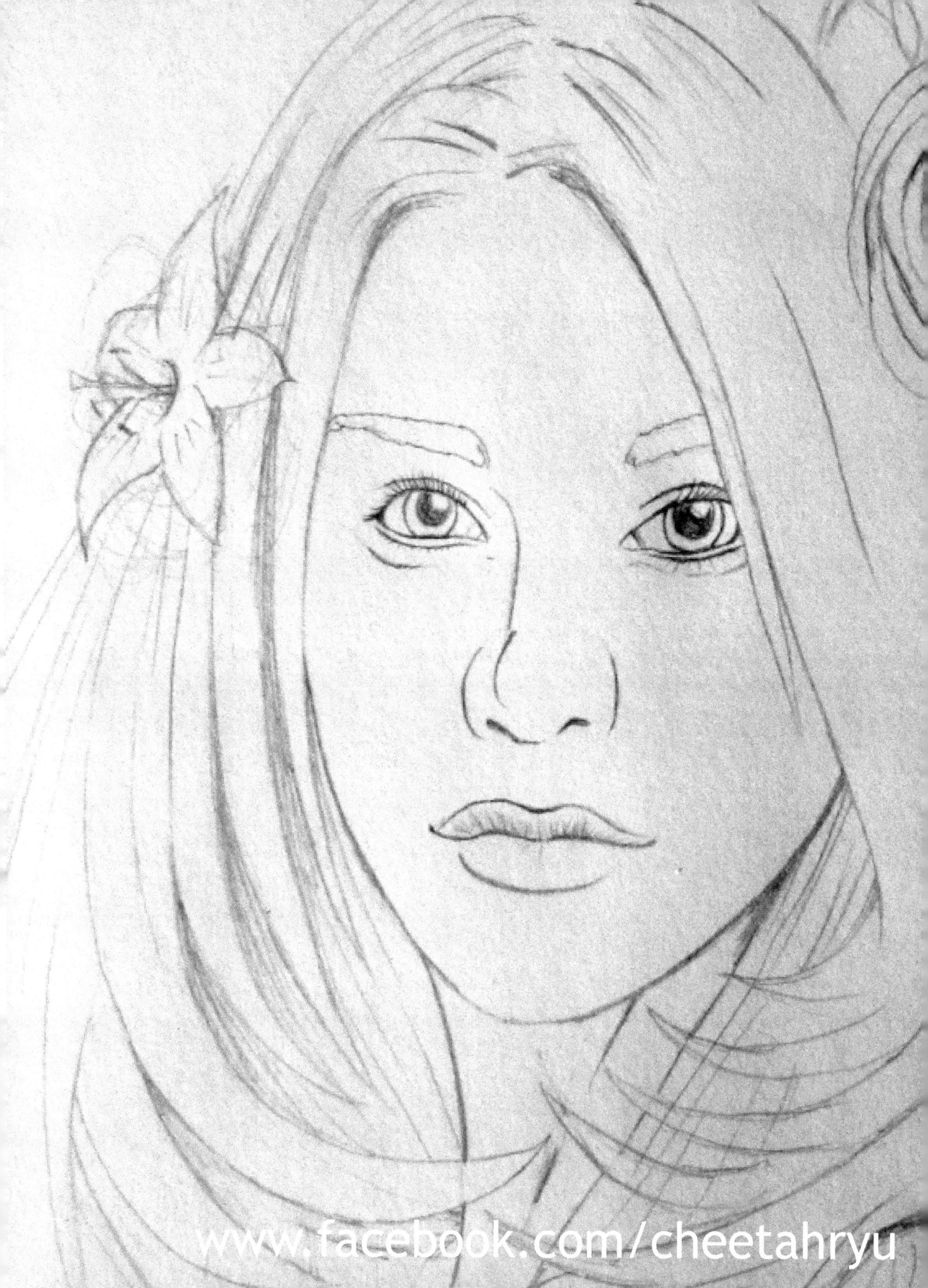

www.ingramcontent.com/pod-product-compliance
Lightning Source LLC
Chambersburg PA
CBHW080556190526
45169CB00007B/2795